Immortal Doodles

Buster Books

Illustrated by Robert McPhillips
Edited by Philippa Wingate

First published in Great Britain in 2010 by Buster Books,
an imprint of Michael O'Mara Books Limited, 9 Lion Yard, Tremadoc Road, London SW4 7NQ

ISBN: 978-1-907151-25-5

2 4 6 8 10 9 7 5 3 1

www.mombooks.com/busterbooks

This book was printed in March 2010 at L.E.G.O., Viale dell'Industria 2, 36100, Vicenza, Italy.

Are you dreaming about
your immortal love?

Design a tattoo fit for
a pack of werewolves.

Create a coat of arms for a family of vampires.

Vampires are impossibly beautiful.
Complete this immortal family.

What is the wolf pack circling?

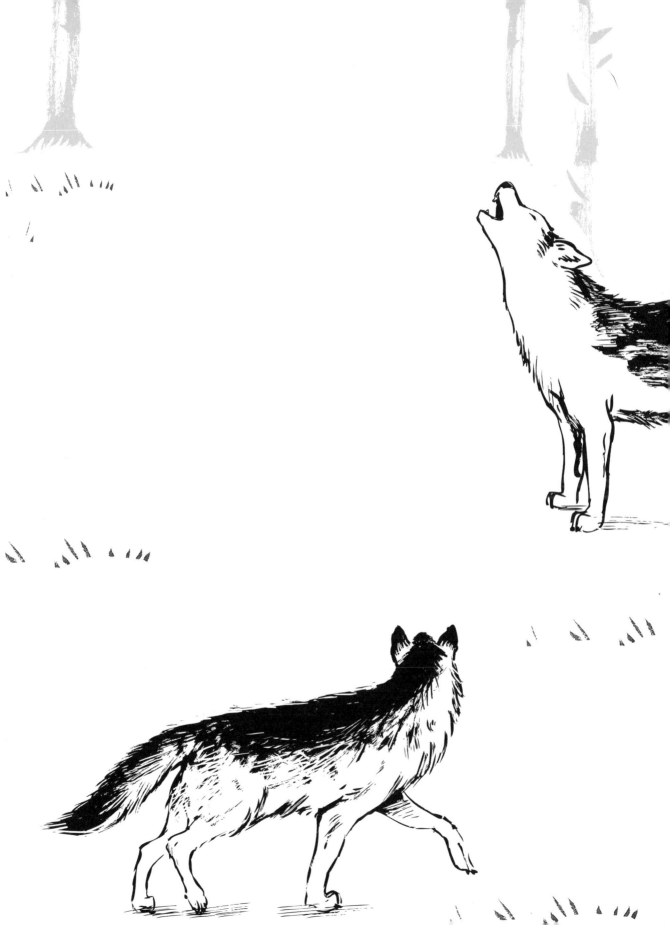

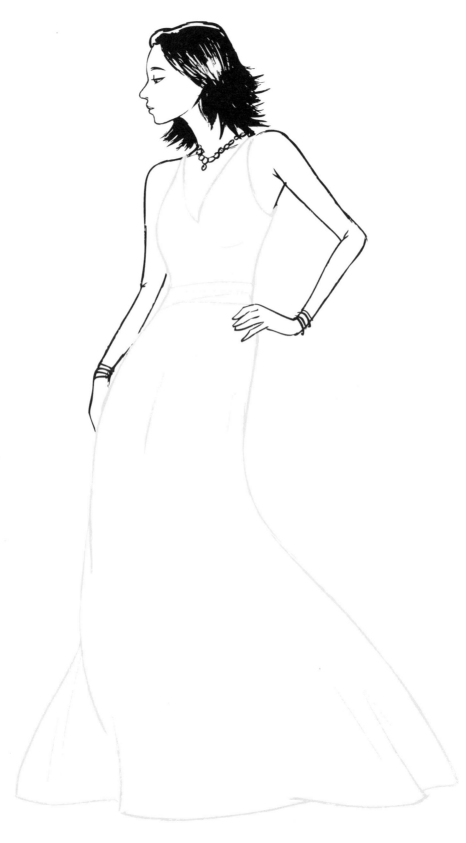

Design a dress to wear to a vampire ball.

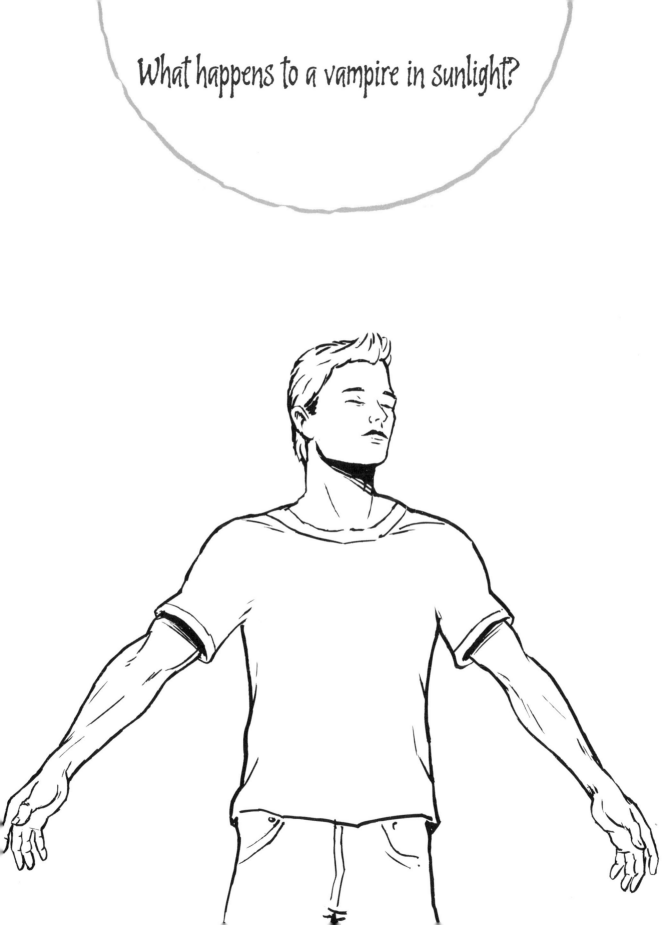

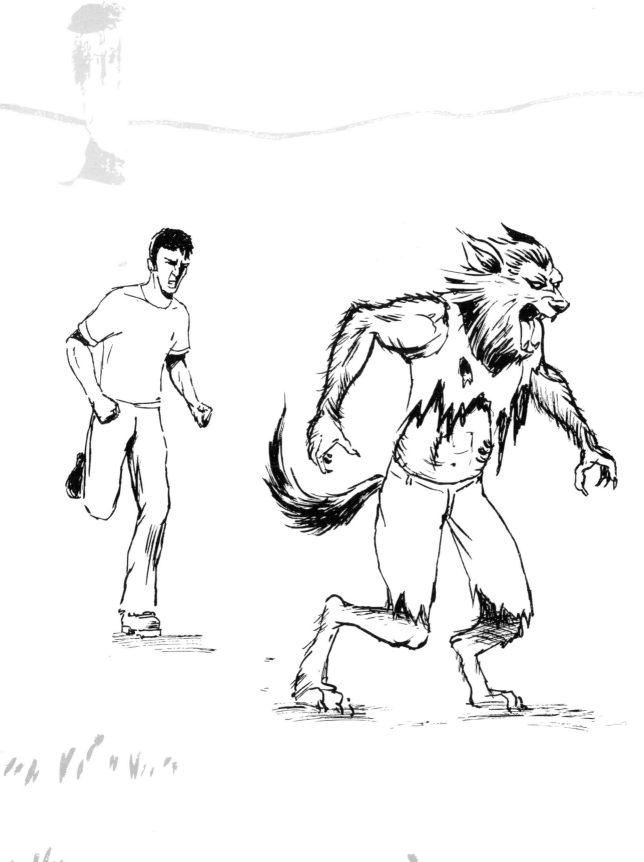

Draw the werewolf after his transformation.

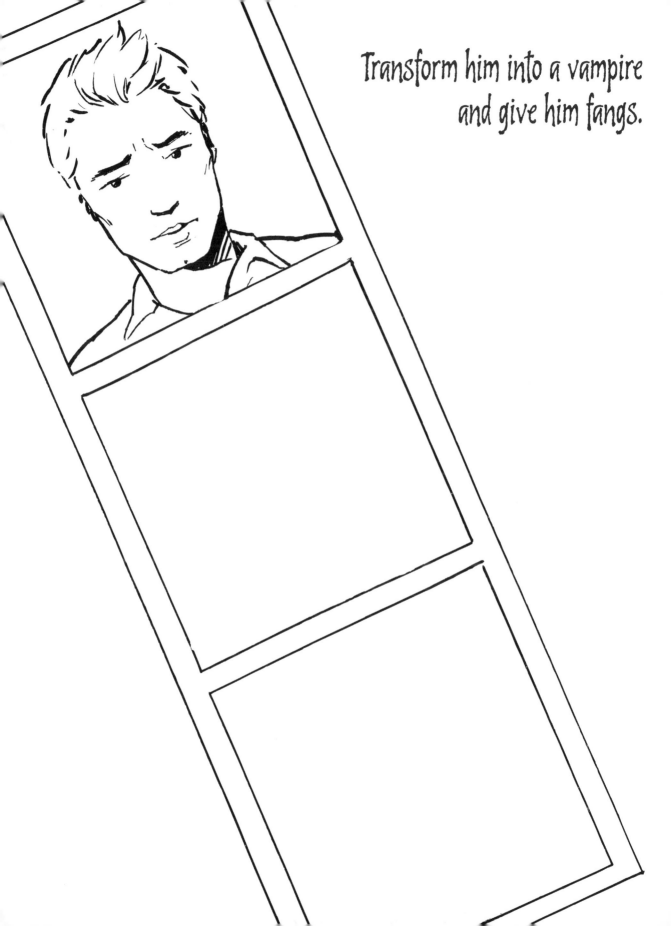

Transform him into a vampire
and give him fangs.

Transform him into a werewolf and give him fur.

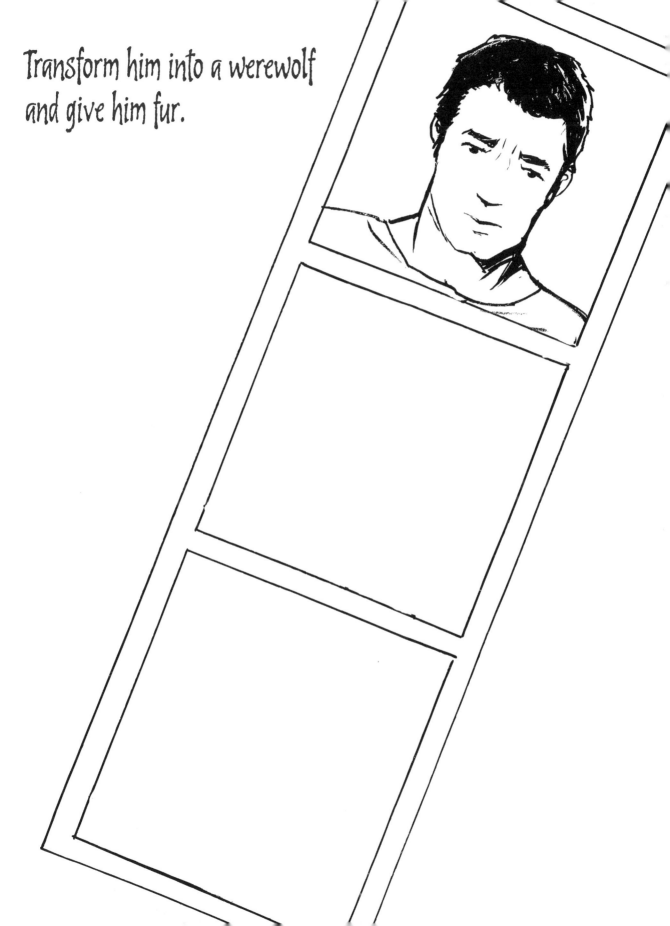

Who is about to bite her?

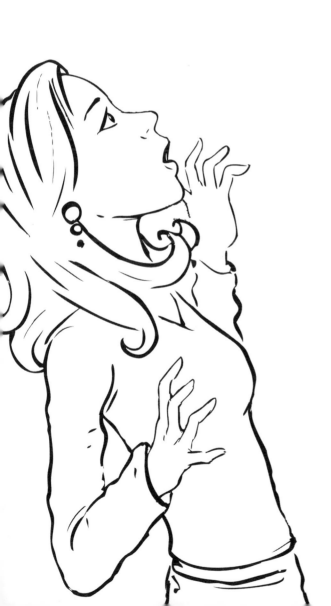

Imagine a royal vampire sitting on this throne.

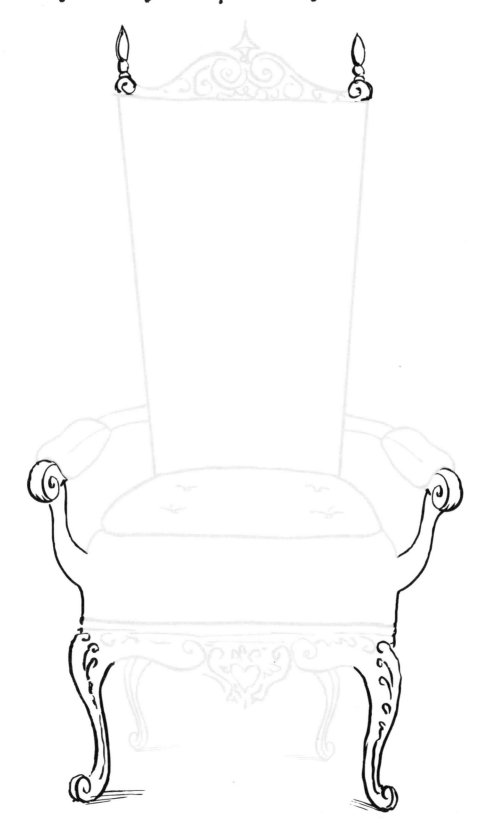

Who wants to be invited in?

Who is the vampire waiting for?

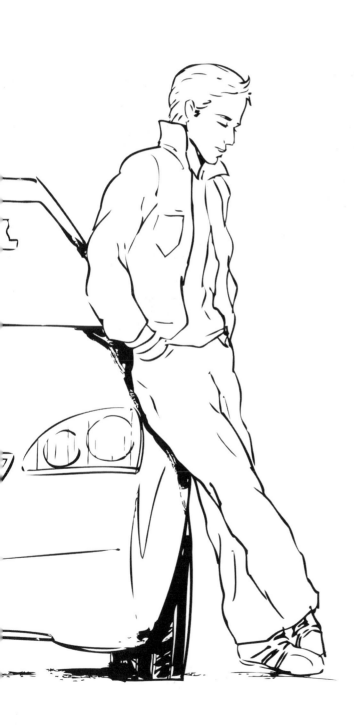

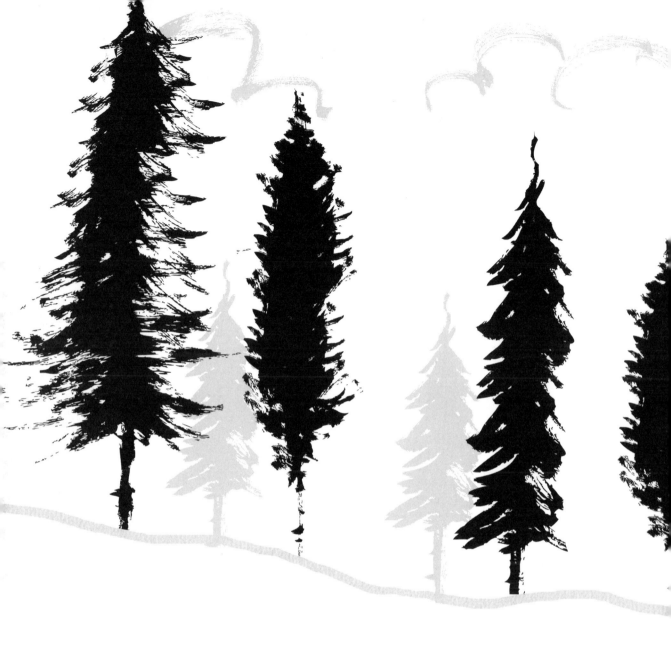

What is out there in the moonlight?

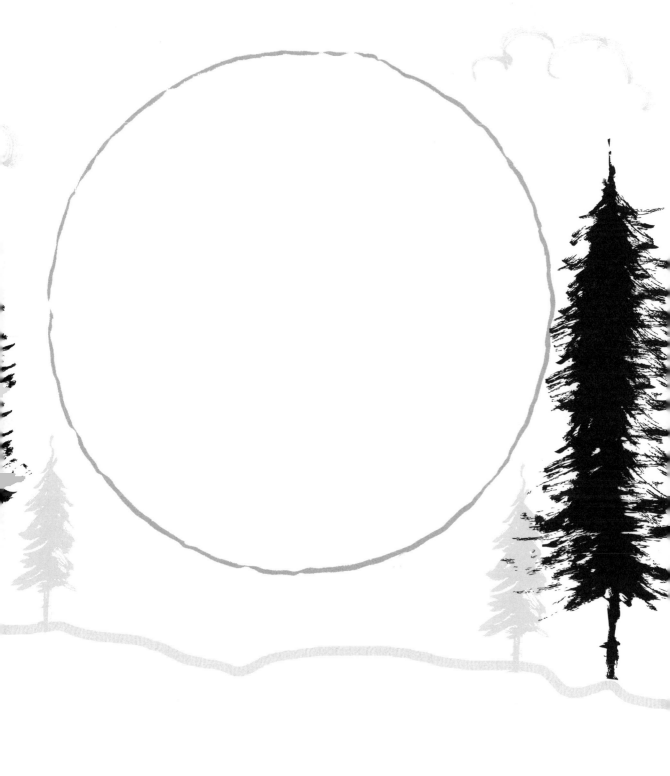

Friend? Foe? Fangs, fur or lovers?

Design T-shirts for Team Vampire . . .

. . . and Team Werewolf.

A mansion made for vampires.

Careful! He can read your mind.

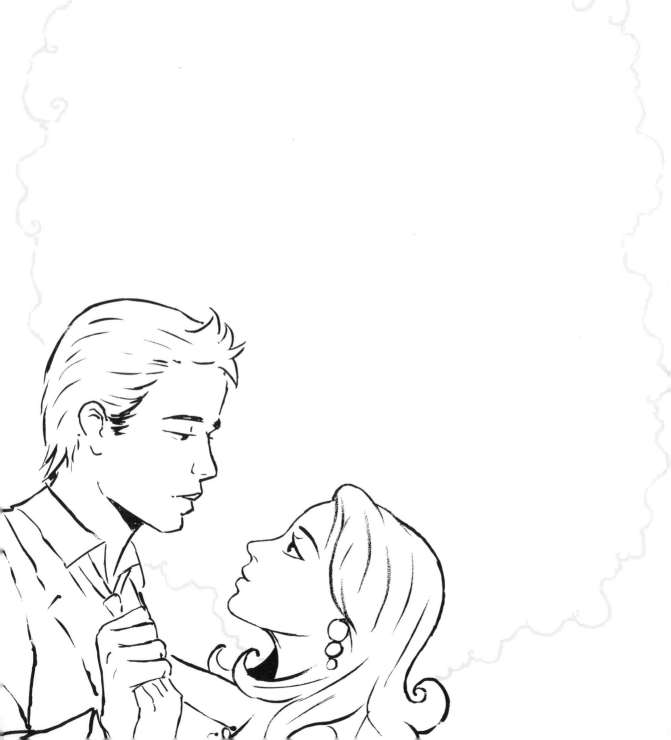

Who is outside her window?

Fill the field with flowers.

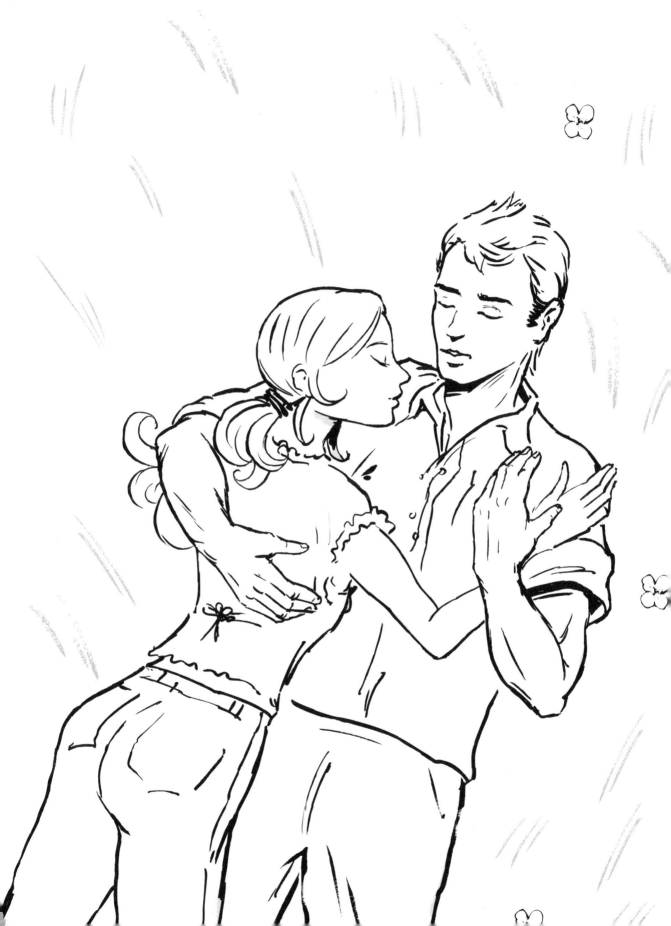

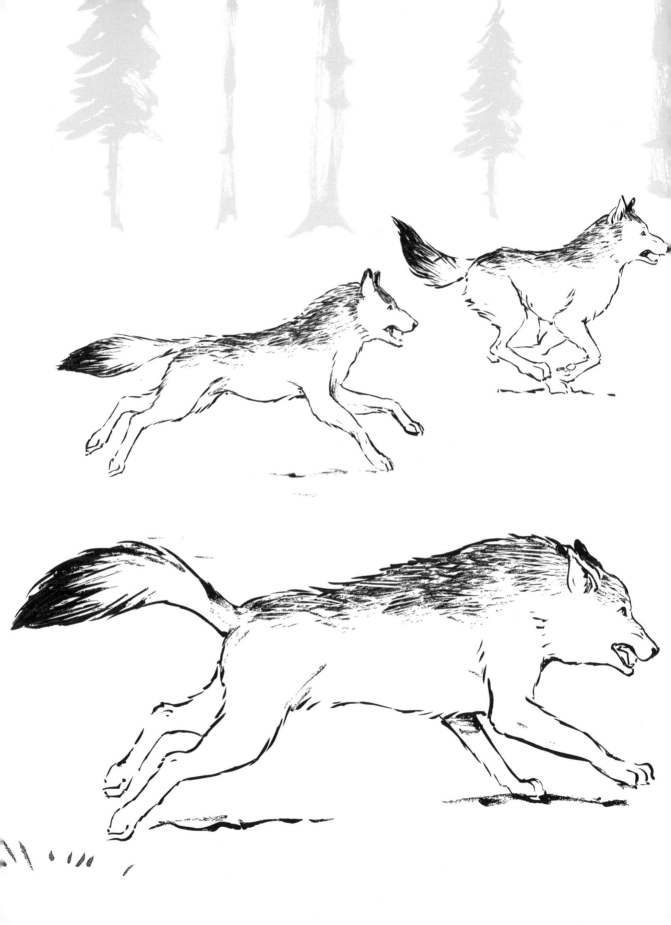

What is the pack chasing?

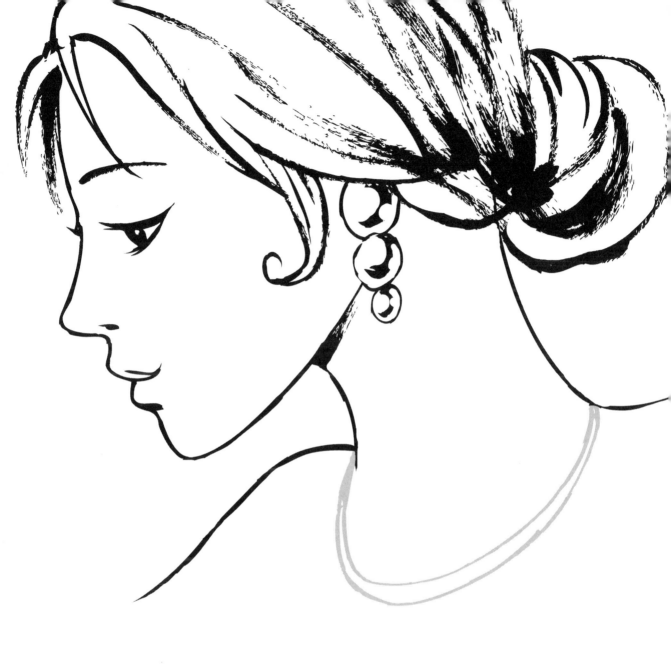

What necklace did your vampire love give you?
Did he bite your neck?

Did he bring roses or wild flowers from a meadow?

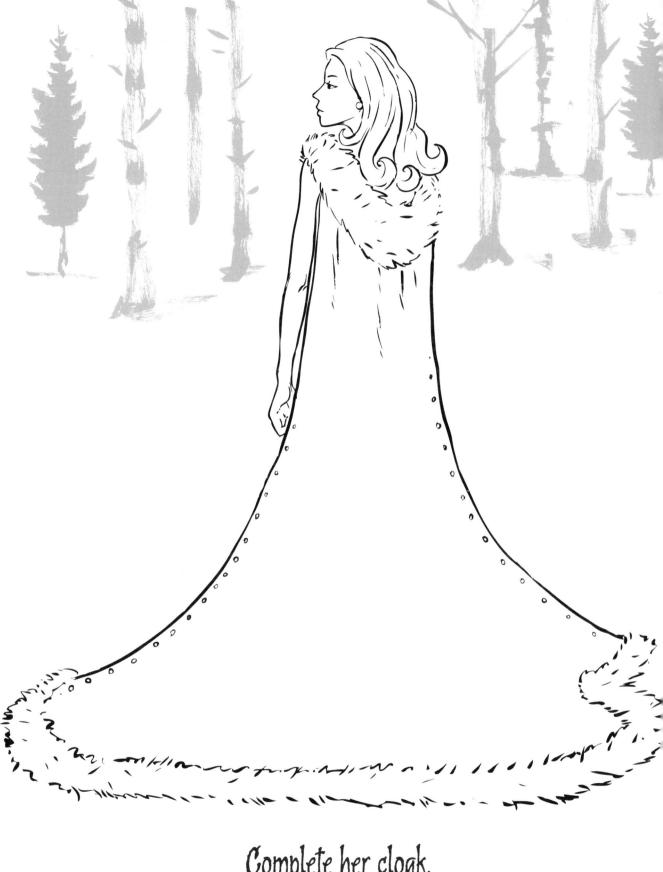

Complete her cloak.

Where does a vampire sleep?

Fill this album with pictures of your dream date.

Werewolves love surfing.
Give them some killer waves to ride.

Doodle statues in front of the vampires' house.

Design a jacket fit for a vampire or a werewolf.

Protect him from the sun.

What can they see?

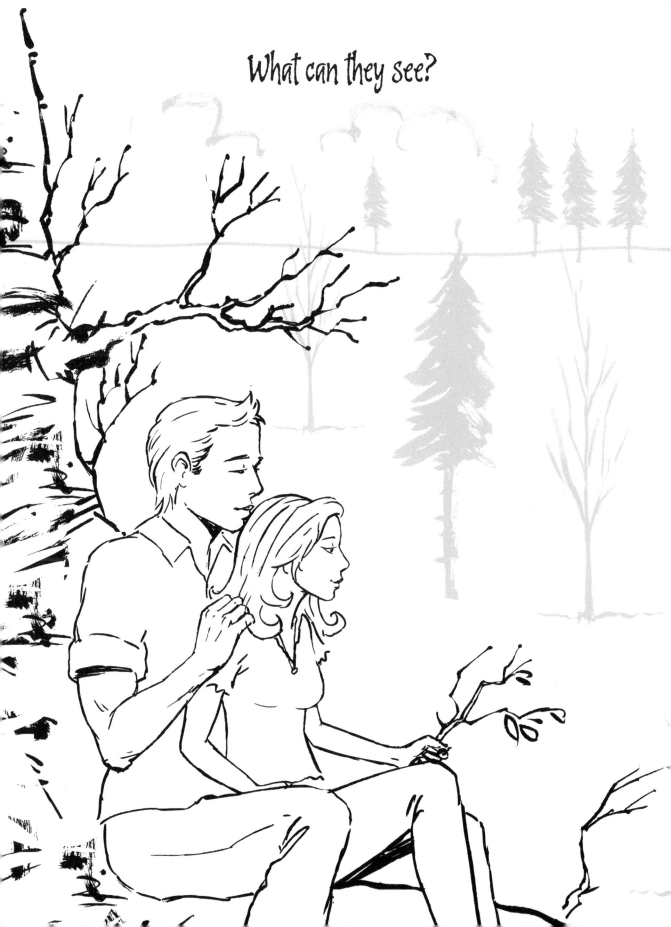

What do you give a vampire for his 250th birthday?

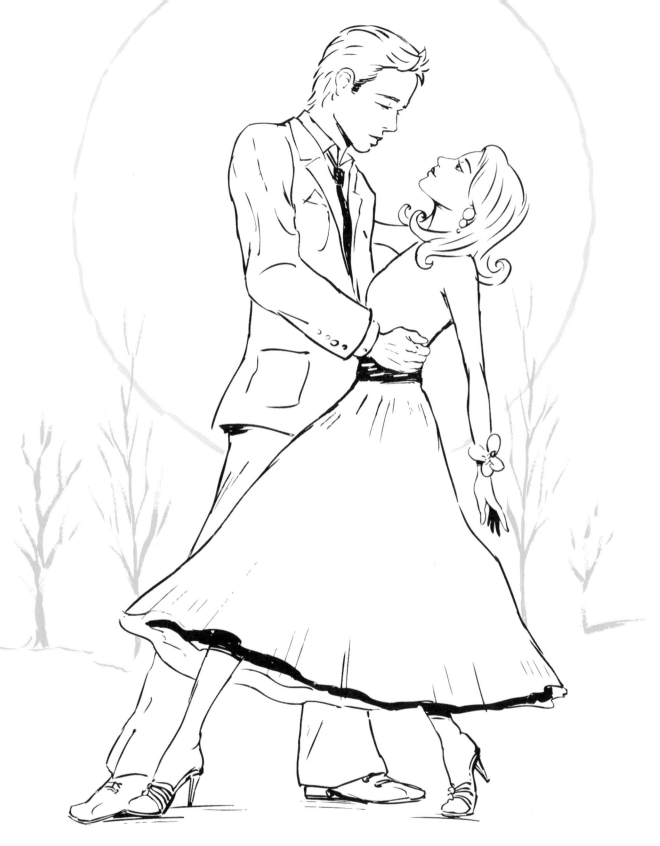

Design your dream dress.

What is in the vampires' lair?

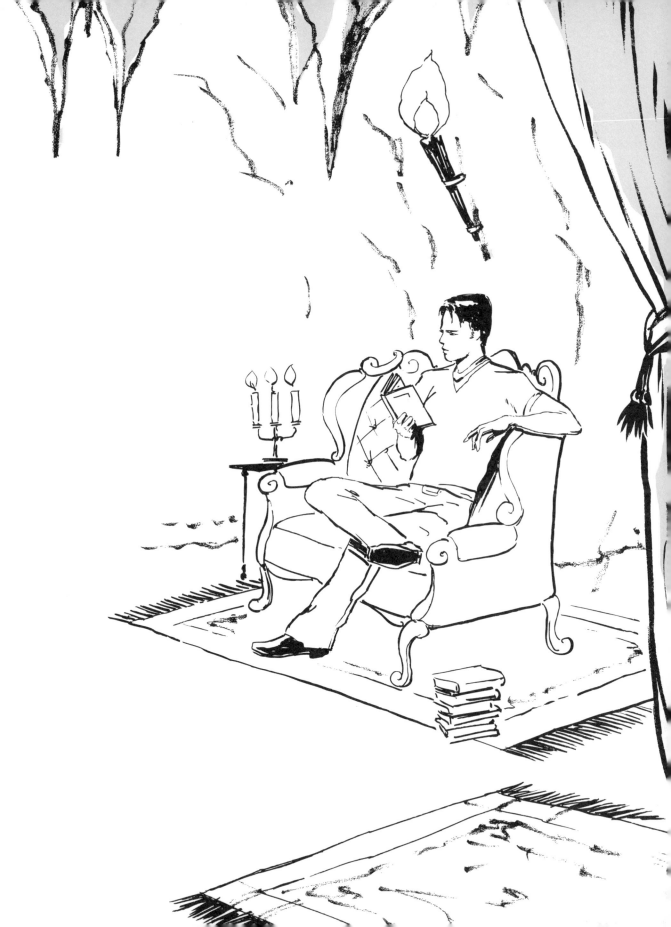

What is the werewolf growling at?

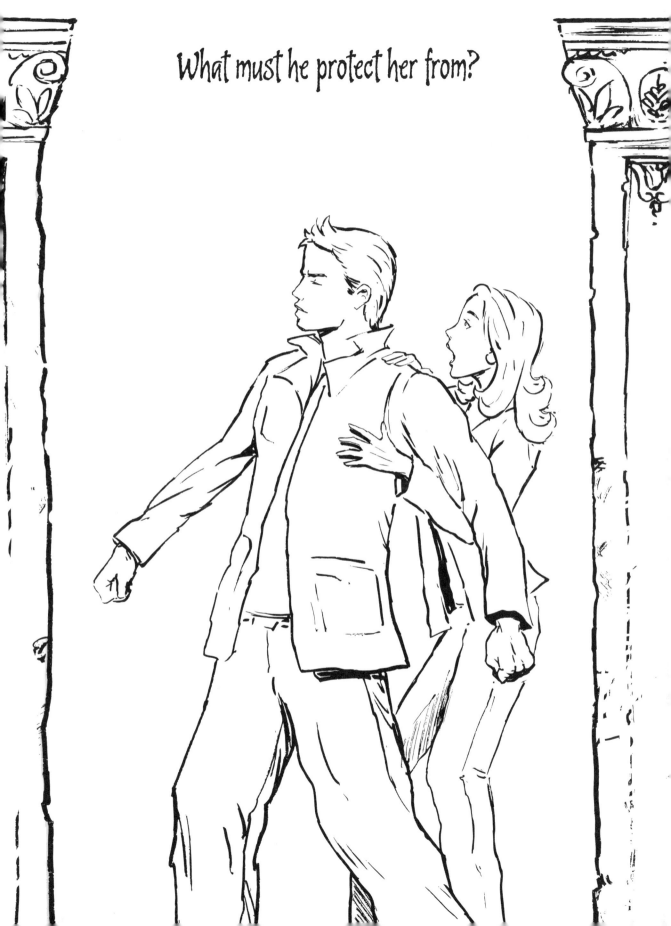

What must he protect her from?

What did she wear when she was human?

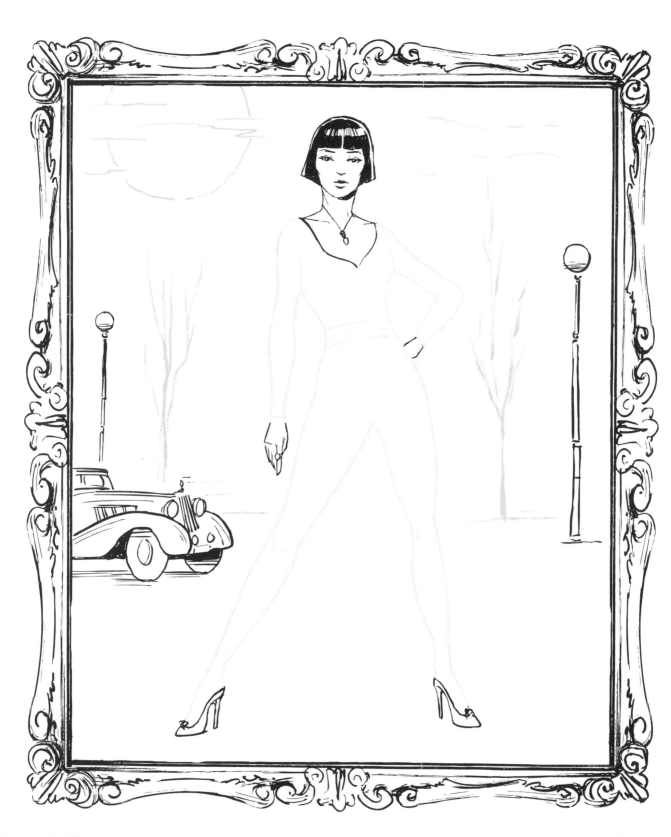

What did he wear when he was human?

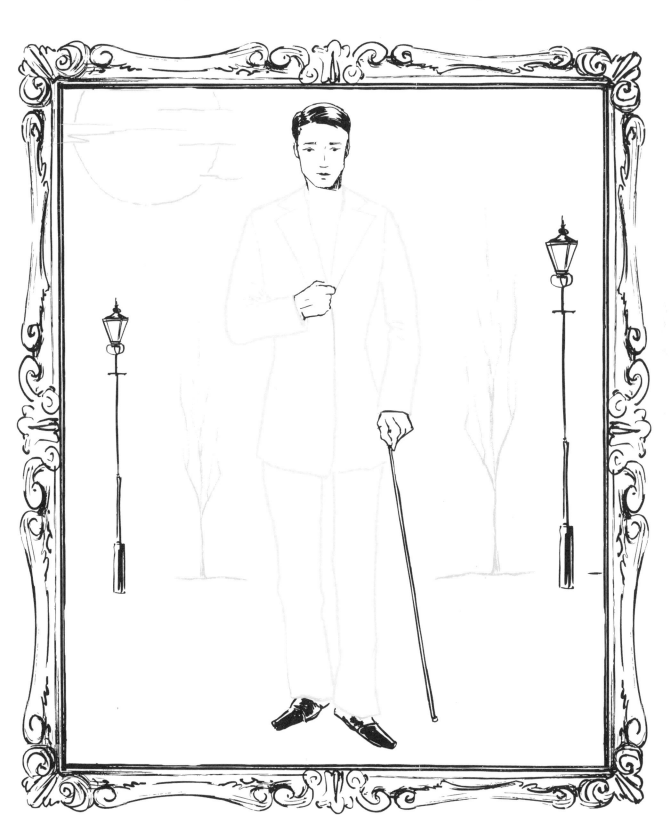

Make this meeting place magical.

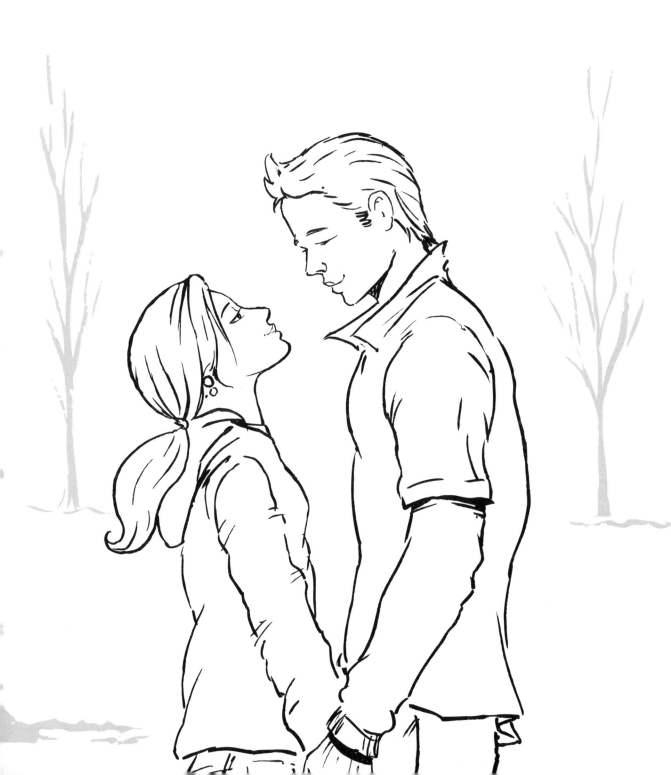

Draw yourself as a vampire.

Cover their wedding arch with flowers.

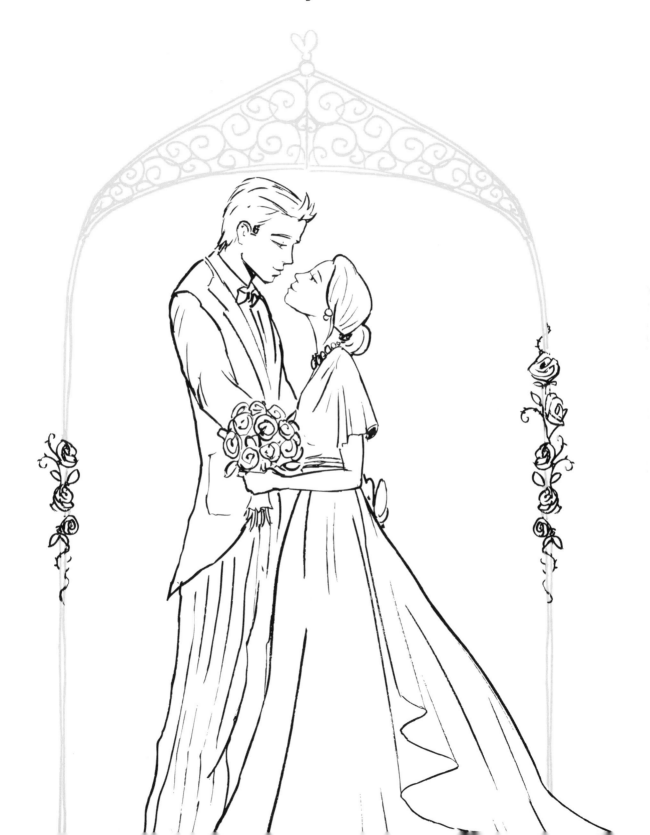

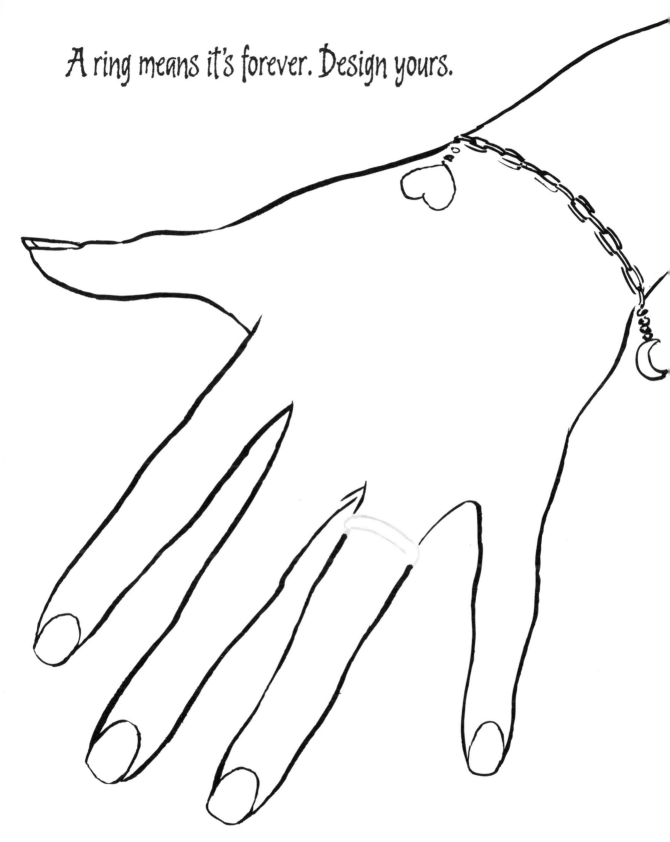

A ring means it's forever. Design yours.

Add beautiful charms to the bracelet, too.

Where would you go on your honeymoon?

Complete the postcard of your romantic destination.

Fill the garden with flowers and fairy lights . . .